BURY ST EDMUNDS IN 50 BUILDINGS

MARTYN TAYLOR

AMBERLEY

Acknowledgements

Thank you to the following for their valued help: David Addy, Bury Free Press, Bury Past & Present Society, Edward Cobbold, St Edmundsbury Borough Council, Robin Goodchild, Tom Griffin, CA Group Ltd, Ron Murrell and Alex McWhirter at Moyses Hall, Dr Pat Murrell, Jack Hobhouse, Marcus Powling and West Suffolk Hospital, Bill O'Kelly, Derek Manning, Stephen Moody, Jarrolds of Norwich, Peter Plumridge, John Saunders, Michael Smith, Alan Gordon-Stables, the Sudbury Society, Suffolk Record Office, Gerry Travers, Anglian Water, Bury and Beyond, and my ever-helpful and patient wife Sandie.

First published 2018

Amberley Publishing, The Hill, Stroud
Gloucestershire GL5 4EP

www.amberley-books.com

Copyright © Martyn Taylor, 2018

The right of Martyn Taylor to be identified as the Author of this work has been asserted in accordance with the Copyrights, Designs and Patents Act 1988.

Map contains Ordnance Survey data © Crown copyright and database right [2018]

British Library Cataloguing in Publication Data.
A catalogue record for this book is available from the British Library.

ISBN 978 1 4456 7943 3 (print)
ISBN 978 1 4456 7944 0 (ebook)

Origination by Amberley Publishing.
Printed in Great Britain.

Contents

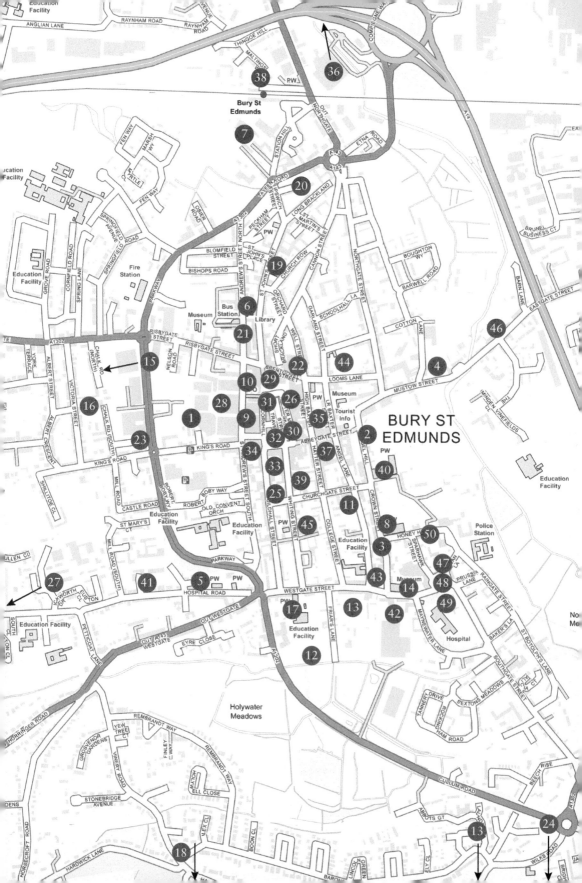

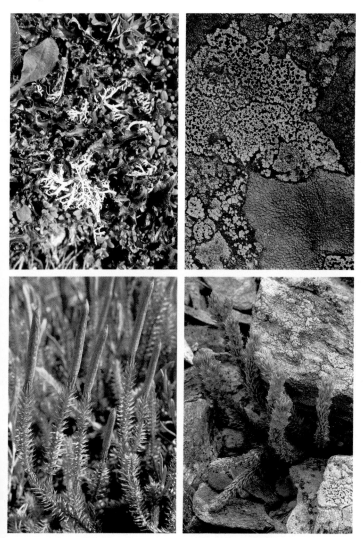

1. White: reindeer moss
 (*Cladonia* sp.).
 Grey-brown: Iceland moss
 (*Cetraria islandica*). ½ ×.

2. Geographical lichen
 (*Rhizocarpon geographicum*)
 and other encrusting lichens. ⅔ ×.

3. Interrupted clubmoss
 (*Lycopodium annotinum*). ½ ×.

4. Fir clubmoss
 (*Lycopodium selago*). ½ ×.

Plate 2 see also p. 123–125

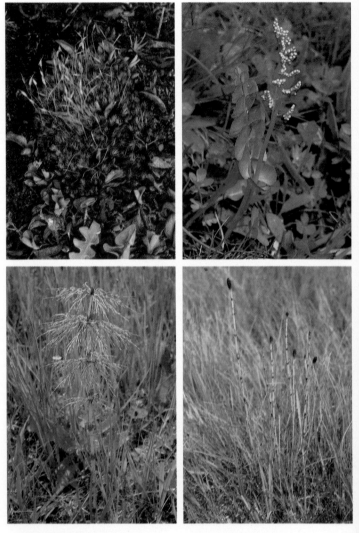

1. Hexagonal haircap-moss
 (*Polytrichum sexangulare*). ½ × .

2. Moonwort
 (*Botrychium lunaria*). ⅔ × .

3. Wood horsetail
 (*Equisetum silvaticum*). ⅓ × .

4. Marsh horsetail
 (*Equisetum palustre*). ⅓ × .

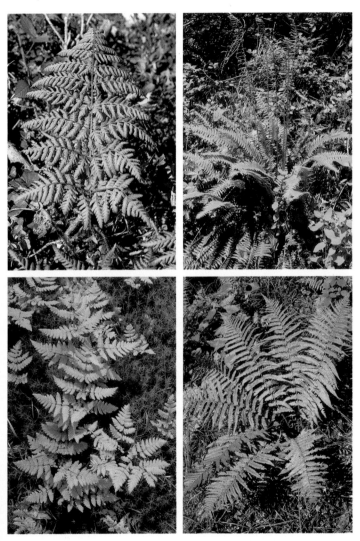

1. Broad buckler-fern
 (Dryopteris dilatata). ⅛ ×.

2. Hard fern
 (Blechnum spicant). ⅙ ×.

3. Disconnected buckler-fern
 (Lastrea dryopteris). ⅙ ×.

4. Male fern
 (Dryopteris filix-mas). ⅛ ×.

Plate 4 see also p. 133–135

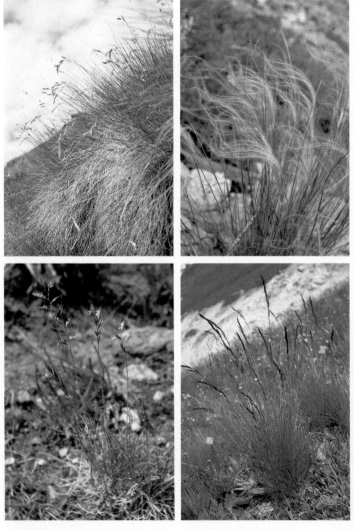

1. Coloured fescue
 (Festuca varia). ⅛ × .

2. Feather-grass
 (Stipa pennata). ⅙ × .

3. Haller's fescue
 (Festuca halleri). ⅓ × .

4. Violet fescue
 (Festuca violacea). ⅛ × .

Plate 5

1. Alpine meadow-grass
 (Poa alpina). ¼ × .

2. Alpine timothy
 (Phleum alpinum). ¼ × .

3. Mat-grass
 (Nardus stricta). ½ × .

4. Two-lined sesleria
 (Sesleria disticha). ½ × .

Plate 6 see also p. 136–137

1. Scheuchzer's cottongrass
 (Eriophorum scheuchzeri). ⅓ ×.

2. Narrow-leaved cottongrass
 (Eriophorum angustifolium). ½ ×.

3. Alpine deergrass
 (Trichophorum alpinum). ⅓ ×.

4. Evergreen sedge
 (Carex sempervirens). ¼ ×.

see also p. 137–139 **Plate 7**

1. Alpine sedge
 (Carex curvula). ½ × .
3. Cushion sedge
 (Carex firma). ⅓ × .

2. Black sedge
 (Carex atrata). ⅕ × .
4. Small-flowered sedge
 (Carex parviflora). 1 × .

Plate 8

see also p. 140

1. Jacquin's rush
 (Juncus jacquinii). ⅔ ×.

2. Three-leaved rush
 (Juncus trifidus). ⅔ ×.

3. Yelow woodrush
 (Luzula lutea). ½ ×.

4. Snow woodrush
 (Luzula nivea). ⅓ ×.

1. Alpine leek
 (Allium victorialis). ⅓ × .
2. Chives
 (Allium schoenoprasum). ¼ × .
3. Greater tofieldia
 (Tofieldia calyculata). ⅓ × .
4. White asphodel
 (Asphodelus albus). ⅙ × .

Plate 10

see also p. 142–143

1. Fire lily
 (*Lilium bulbiferum*). ⅓ ×.

2. Martagon lily
 (*Lilium martagon*). ⅓ ×.

3. White false hellebore
 (*Veratrum album*). ⅛ ×.

4. St. Bruno's lily
 (*Paradisia liliastrum*). ½ ×.

Plate 11

1. Snowdon lily
 (Lloydia serotina). ½ × .

2. Yellow star-of-Bethlehem
 (Gagea fistulosa). ½ × .

3. Alpine meadow-saffron
 (Colchicum alpinum). ¾ × .

4. Spring meadow-saffron
 (Colchicum bulbocodium). ⅔ × .

Plate 12 see also p. 144–145

1. Whorled Solomon's seal
 (Polygonatum verticillatum). ⅓ ×.

2. Spring snowflake
 (Leucojum vernum). ½ ×.

3. Narrow-leaved daffodil
 (Narcissus radiiflorus). ⅓ ×.

4. White crocus
 (Crocus vernus). ½ ×.

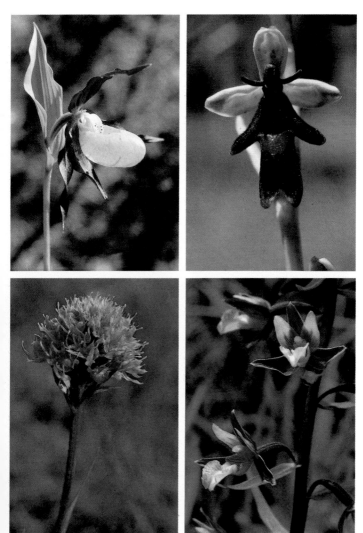

1. Lady's slipper
 (Cypripedium calceolus). ½ ×.
2. Fly orchid
 (Ophrys insectifera). 2 ×.
3. Globose orchid
 (Orchis globosa). 1 ×.
4. Marsh helleborine
 (Epipactis palustris). 1½ ×.

Plate 14 see also p. 146

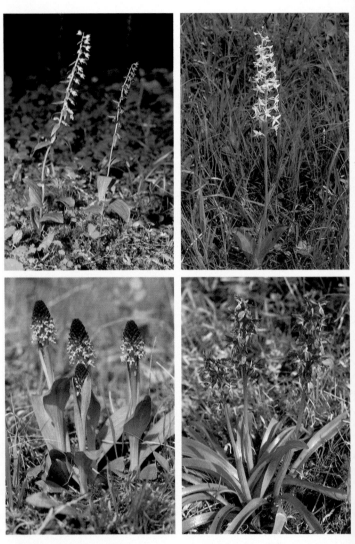

1. Left: broad-leaved helleborine
 (Epipactis latifolia).
 Right: dark-red helleborine
 (Epipactis atropurpurea). ⅕ × .

2. Lesser butterfly orchid
 (Platanthera bifolia). ¼ × .

3. Dark-winged orchid
 (Orchis ustulata). ⅓ × .

4. Blue butcher
 (Orchis mascula). ⅓ × .

Plate 15

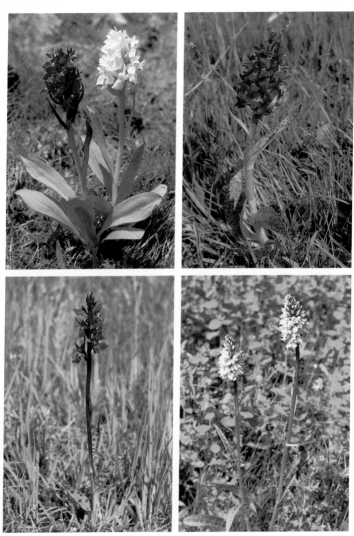

1. Elder orchid
 (Orchis sambucina). ⅓ × .

2. Broad-leaved orchid
 (Orchis latifolia). ⅓ × .

3. Traunsteiner's orchid
 (Orchis traunsteineri). ⅓ × .

4. Spotted orchid
 (Orchis maculata). ¼ × .

Plate 16

see also p. 147–148

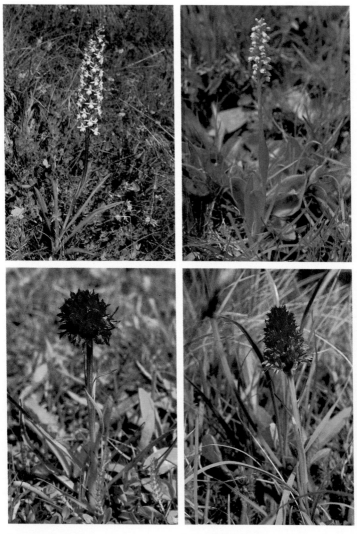

1. Fragrant orchid
 (*Gymnadenia conopea*). ⅓ ×.

2. Small white orchid
 (*Leucorchis albida*). ⅓ ×.

3. Black vanilla orchid
 (*Nigritella nigra*). ¾ ×.

4. Red vanilla orchid
 (*Nigritella rubra*). ⅔ ×.

see also p. 148–149 **Plate 17**

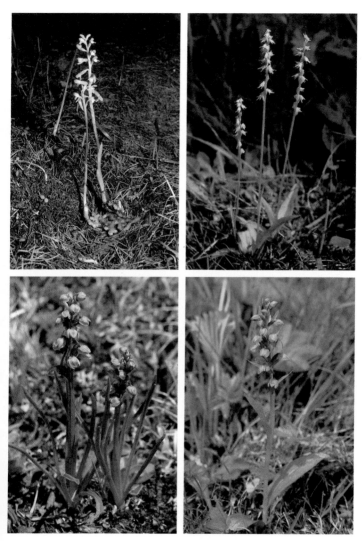

1. Coral-root
 (*Corallorhiza trifida*). ⅓ × .
2. Musk-orchid
 (*Herminium monorchis*). ⅓ × .
3. Alpine dwarf orchid
 (*Chamorchis alpina*). ⅔ × .
4. Frog orchid
 (*Coeloglossum viride*). ½ × .

Plate 18 see also p. 150

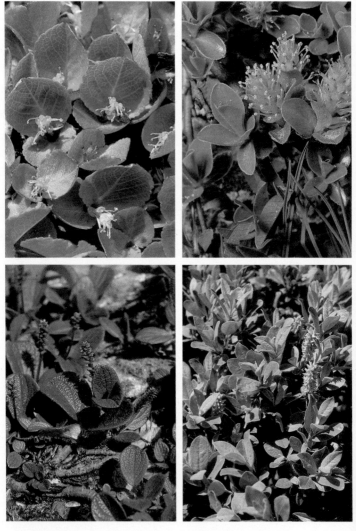

1. Dwarf willow
 (Salix herbacea). 1½ ×.

2. Blunt-leaved willow
 (Salix retusa). 1 ×.

3. Net-leaved willow
 (Salix reticulata). ½ ×.

4. Swiss willow
 (Salix helvetica). ⅕ ×.

Plate 19

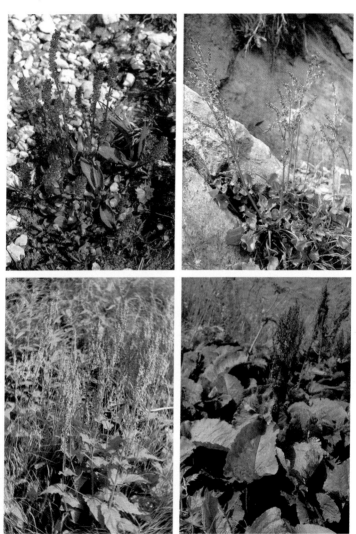

1. Snow dock
 (*Rumex nivalis*). ⅓ × .

2. French sorrel
 (*Rumex scutatus*). ⅕ × .

3. Mountain sorrel
 (*Rumex arifolius*). 1/10 × .

4. Monk's rhubarb
 (*Rumex alpinus*). 1/10 × .

Plate 20

see also p. 153

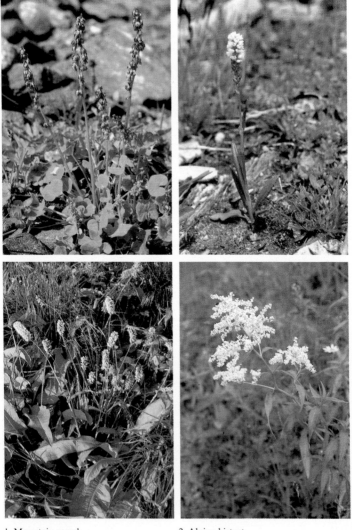

1. Mountain sorrel
 (Oxyria digyna). ½ ×.

2. Alpine bistort
 (Polygonum viviparum). ⅓ ×.

3. Common bistort
 (Polygonum bistorta). ⅙ ×.

4. Alpine knotgrass
 (Polygonum alpinum). ¼ ×.

Plate 21

1. Alpine bastard toadflax
 (*Thesium alpinum*). ⅓ ×.

2. All-good
 (*Chenopodium bonus-henricus*). ⅕ ×.

3. Rock campion
 (*Silene rupestris*). ⅓ ×.

4. Gypsophila
 (*Gypsophila repens*). ½ ×.

Plate 22 see also p. 154–155

1. Nottingham catchfly
 (Silene nutans). ¼ ×.

2. Bladder campion
 (Silene vulgaris). ⅓ ×.

3. Fountain campion
 (Silene quadridentata). ⅓ ×.

4. Scapeless moss campion
 (Silene exscapa). ½ ×.

1. Red alpine catchfly
 (Silene liponeura). ½ × .
2. Jupiter catchfly
 (Silene flos-jovis). ⅕ × .
3. Red campion
 (Silene dioeca). ⅓ × .
4. Rock soapwort
 (Saponaria ocymoides). ⅔ × .

Plate 24

see also p. 156

1. Superb pink
 (*Dianthus superbus*). ⅕ × .

2. Wood pink
 (*Dianthus silvester*). ¼ × .

3. Glacial pink
 (*Dianthus glacialis*). ¾ × .

4. Carthusian pink
 (*Dianthus carthusianorum*). ⅓ × .

Plate 25

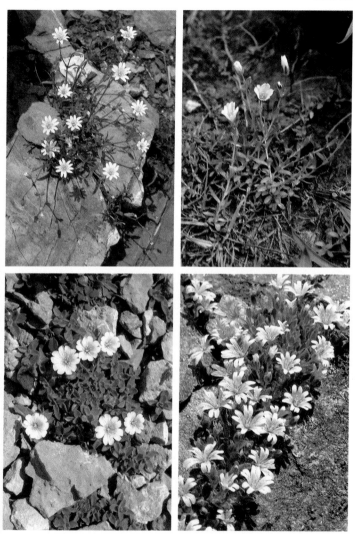

1. Rigid mouse-ear
 (Cerastium strictum). ⅓ ×.

2. Starwort mouse-ear
 (Cerastium trigynum). ½ ×.

3. Broad-leaved mouse-ear
 (Cerastium latifolium). ⅓ ×.

4. One-flowered mouse-ear
 (Cerastium uniflorum). ½ ×.

Plate 26 see also p. 157–159

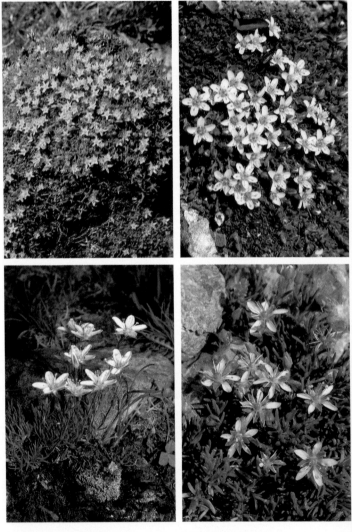

1. Mossy cyphal sandwort
 (*Minuartia sedoides*). ²/₃ × .

2. Two-flowered sandwort
 (*Arenaria biflora*). ³/₄ × .

3. Curved sandwort
 (*Minuartia recurva*). ³/₄ × .

4. Ciliated moehringia
 (*Moehringia ciliata*). 1 × .

see also p. 159–160 **Plate 27**

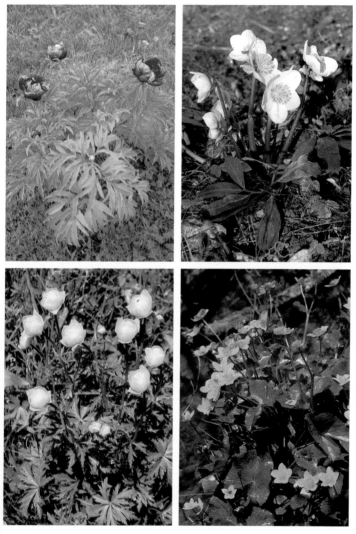

1. Wild peony
 (Paeonia officinalis). ⅛ × .
2. Christmas rose
 (Helleborus niger). ¼ × .
3. Globe flower
 (Trollius europaeus). ⅕ × .
4. Marsh-marigold
 (Caltha palustris). ⅕ × .

Plate 28

see also p. 160

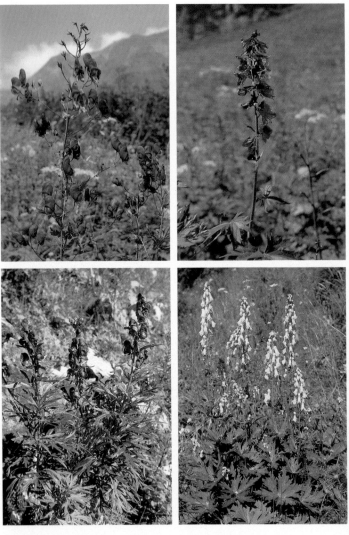

1. Paniculate aconite
 (Aconitum paniculatum). ⅙ × .

2. Alpine larkspur
 (Delphinium elatum). ⅙ × .

3. Common monkshood
 (Aconitum napellus). ⅛ × .

4. Wolfbane aconite
 (Aconitum lycoctonum). ¹⁄₁₂ × .

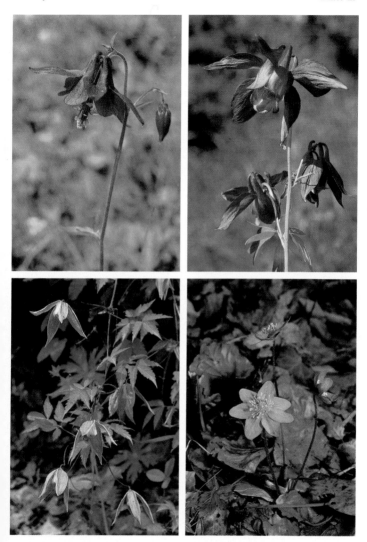

1. Common columbine
 (Aquilegia vulgaris). ¾ × .
2. Alpine columbine
 (Aquilegia alpina). ½ × .
3. Alpine virgin'sbower
 (Clematis alpina). ⅓ × .
4. Hepatica
 (Hepatica triloba). ¾ × .

Plate 30 see also p. 162–163

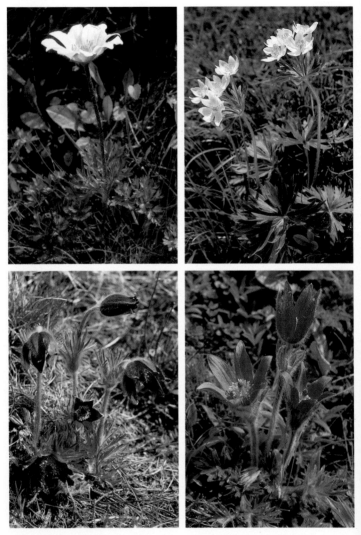

1. Mt. Baldo anemone
 (*Anemone baldensis*). ⅔ × .

2. Narcissus-flowered anemone
 (*Anemone narcissiflora*). ⅓ × .

3. Mountain pasqueflower
 (*Pulsatilla montana*). ⅓ × .

4. Haller's pasqueflower
 (*Pulsatilla halleri*). ½ × .

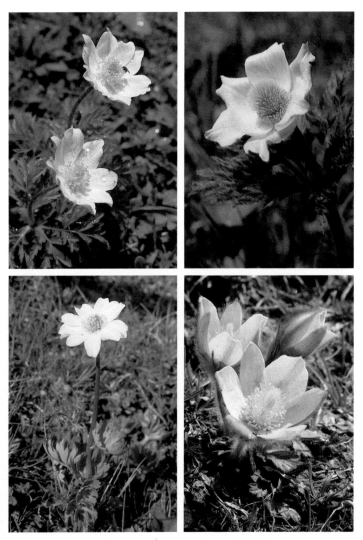

1. White alpine pasqueflower
 (*Pulsatilla alpina*). ½ × .

2. Yellow alpine pasqueflower
 (*Pulsatilla sulphurea*). ⅔ × .

3. Coriander-leaved callianthemum
 (*Callianthemum coriandrifolium*). ¾ × .

4. Spring pasqueflower
 (*Pulsatilla vernalis*). ¾ × .

Plate 32

see also p. 164

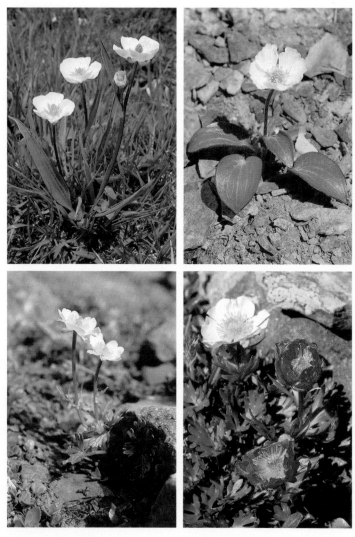

1. Pyrenean buttercup
 (*Ranunculus pyrenaeus*). ½ × .

2. Grass-of-Parnassus-leaved buttercup
 (*Ranunculus parnassifolius*). ⅔ × .

3. Alpine buttercup
 (*Ranunculus alpester*). ½ × .

4. Glacial crowfoot
 (*Ranunculus glacialis*). ¾ × .

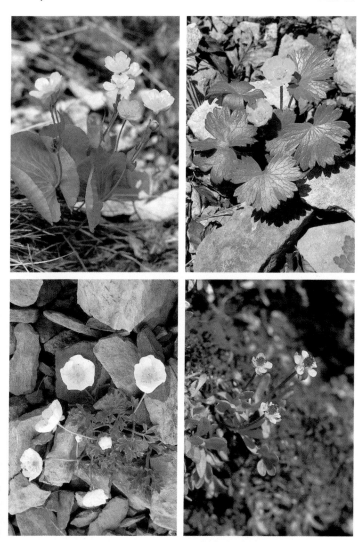

1. Thora buttercup
 (*Ranunculus thora*). ½ ×.

2. Mountain buttercup
 (*Ranunculus montanus*). ½ ×.

3. Seguier's buttercup
 (*Ranunculus seguieri*). ½ ×.

4. Dwarf buttercup
 (*Ranunculus pygmaeus*). ¾ ×.

Plate 34

see also p. 165

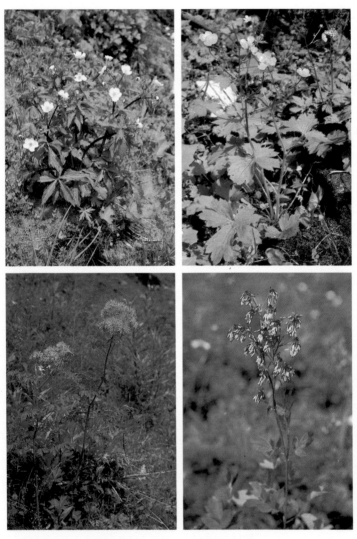

1. Aconite-leaved buttercup
 (*Ranunculus aconitifolius*). ¼ × .

2. Woolly crowfoot
 (*Ranunculus lanuginosus*). ⅓ × .

3. Columbine-leaved meadow-rue
 (*Thalictrum aquilegiifolium*). ⅙ × .

4. Lesser meadow-rue
 (*Thalictrum minus*). ½ × .

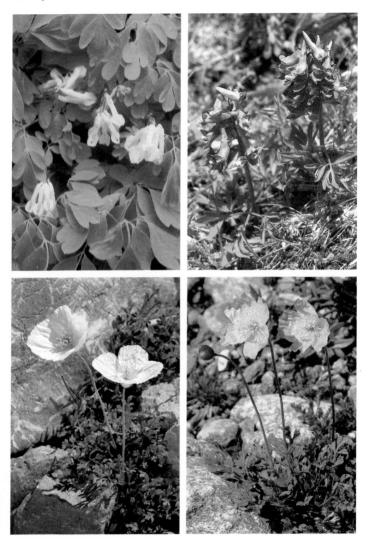

1. Yellow fumitory
 (Corydalis lutea). ⅔ ×.

2. Tuberous fumitory
 (Corydalis solida). ⅔ ×.

3. Alpine poppy
 (Papaver alpinum). ½ ×.

4. Orange poppy
 (Papaver aurantiacum). ½ ×.

Plate 36 see also p. 168

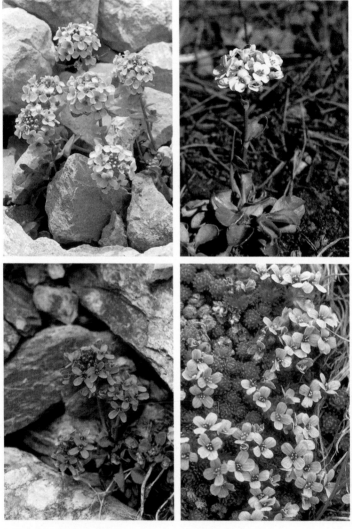

1. Round-leaved pennycress
 (Thlaspi rotundifolium). ½ × .

2. Mountain pennycress
 (Thlaspi montanum). ⅔ × .

3. Corymbose pennycress
 (Thlaspi corymbosum). ⅔ × .

4. Pyrenean petrocallis
 (Petrocallis pyrenaica). ¾ × .

Plate 37

1. Buckler mustard
 (Biscutella levigata). ¼ ×.

2. Erucastrum
 (Erucastrum nasturtiifolium). ⅛ ×.

3. Rock kernera
 (Kernera saxatilis). ⅓ ×.

4. Alpine hutchinsia
 (Hutchinsia alpina). ⅔ ×.

Plate 38 see also p. 169, 171

1. Carinthian draba
 (*Draba carinthiaca*). ½ ×.

2. Evergreen draba
 (*Draba aizoides*). ⅔ ×.

3. Reseda bittercress
 (*Cardamine resedifolia*). ½ ×.

4. Alpine bittercress
 (*Cardamine alpina*). ⅔ ×.

Plate 39

1. Large bittercress
 (Cardamine amara). ⅓ × .

2. Rivulet bittercress
 (Cardamine rivularis). ½ × .

3. Pinnate bittercress
 (Cardamine heptaphylla). ¼ × .

4. Perennial honesty
 (Lunaria rediviva). ⅓ × .

Plate 40 see also p. 172

1. Bluish rockcress
 (Arabis coerulea). ¾ × .

2. Dwarf rockcress
 (Arabis pumila). ⅔ × .

3. Alpine rockcress
 (Arabis alpina). ⅓ × .

4. Jacquin's rockcress
 (Arabis jacquinii). ⅔ × .

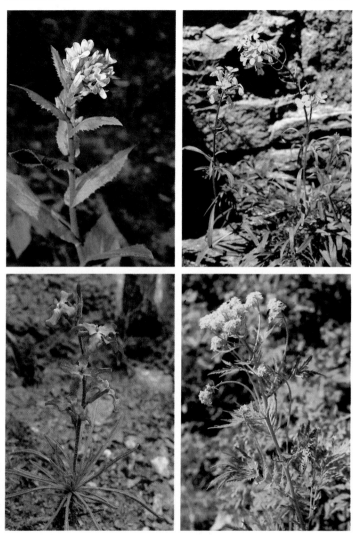

1. Tower rockcress
 (*Arabis turrita*). ²⁄₃ × .

2. Swiss treacle-mustard
 (*Erysimum helveticum*). ¹⁄₄ × .

3. Alpine stock
 (*Matthiola vallesiaca*). ²⁄₃ × .

4. Tansy-leaved rocket
 (*Hugueninia tanacetifolia*). ¹⁄₄ × .

Plate 42

see also p. 173–174

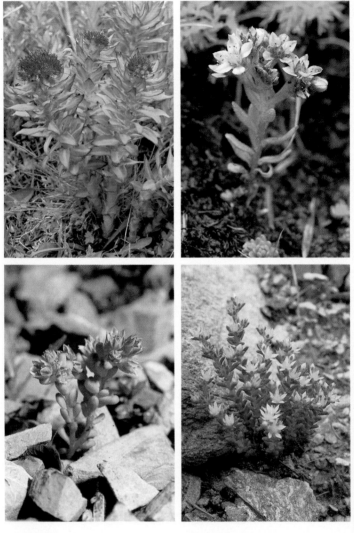

1. Rose-root
 (Sedum rosea). ⅓ ×.

2. Hairy stonecrop
 (Sedum villosum). 1 ×.

3. Blackish stonecrop
 (Sedum atratum). 1 ×.

4. Annual stonecrop
 (Sedum annuum). ⅔ ×.

Plate 43

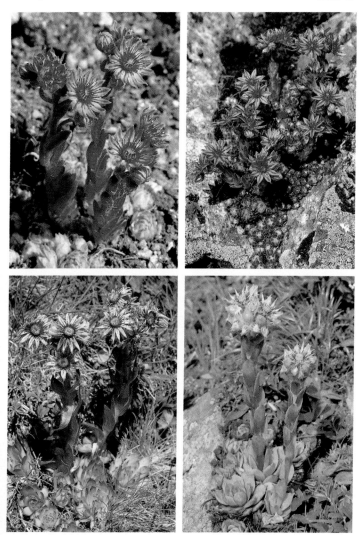

1. Mountain housekeek
 (Sempervivum montanum). ½ ×.

2. Cobwebby houseleek
 (Sempervivum arachnoideum). ½ ×.

3. Alpine houseleek
 (Sempervivum alpinum). ⅓ ×.

4. Wulfen's houseleek
 (Sempervivum wulfenii). ⅓ ×.

Plate 44 see also p. 175

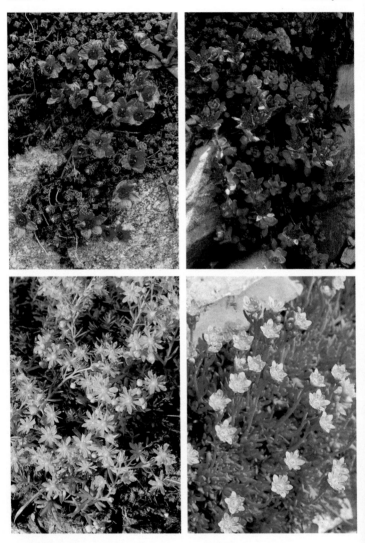

1. Purple saxifrage
 (Saxifraga oppositifolia). ⅔ ×.

2. Two-flowered saxifrage
 (Saxifraga biflora). ⅔ ×.

3. Yellow mountain saxifrage
 (Saxifraga aizoides). ½ ×.

4. Musky saxifrage
 (Saxifraga moschata). ½ ×.

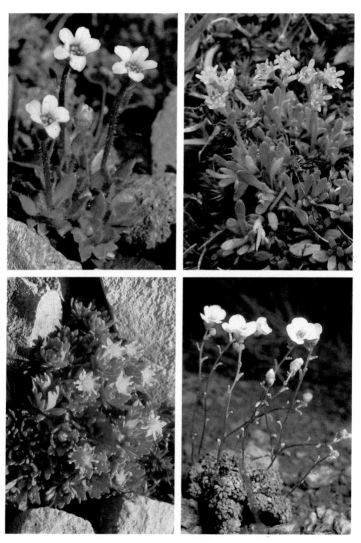

1. Androsace-like saxifrage
 (Saxifraga androsacea). 1 × .
2. Seguier's saxifrage
 (Saxifraga seguieri). ¾ × .
3. Saxifrage with naked stems
 (Saxifraga aphylla). ¾ × .
4. Bluish saxifrage
 (Saxifraga caesia). ⅔ × .

Plate 46 see also p. 176–177

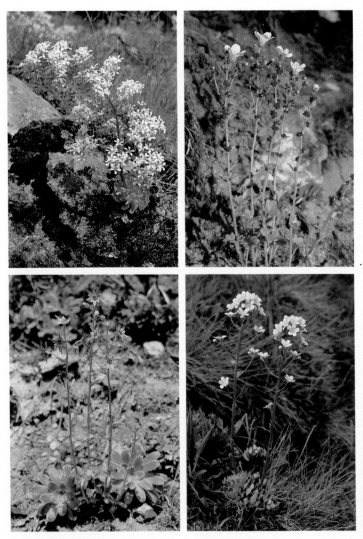

1. Pyramidal saxifrage
 (*Saxifraga cotyledon*). ¼ ×.

2. Drooping saxifrage
 (*Saxifraga cernua*). ½ ×.

3. Orange-red saxifrage
 (*Saxifraga mutata*). ⅓ ×.

4. White mountain saxifrage
 (*Saxifraga aizoon*). ⅓ ×.

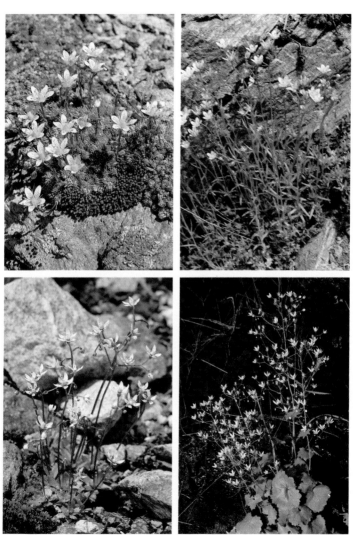

1. Moss saxifrage
 (Saxifraga bryoides). ½ ×.

2. Stiff-haired saxifrage
 (Saxifraga aspera). ¼ ×.

3. Stellate saxifrage
 (Saxifraga stellaris). ½ ×.

4. Round-leaved saxifrage
 (Saxifraga rotundifolia). ⅕ ×.

Plate 48 see also p. 178–179

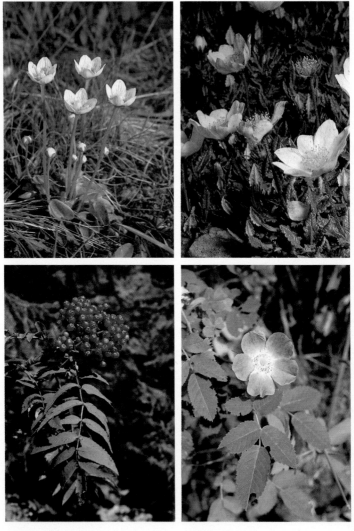

1. Grass of Parnassus
 (Parnassia palustris). ⅓ × .
2. Mountain avens
 (Dryas octopetala). ⅔ × .
3. Rowan
 (Sorbus aucuparia). ¼ × .
4. Alpine rose
 (Rosa pendulina). ½ × .

Plate 49

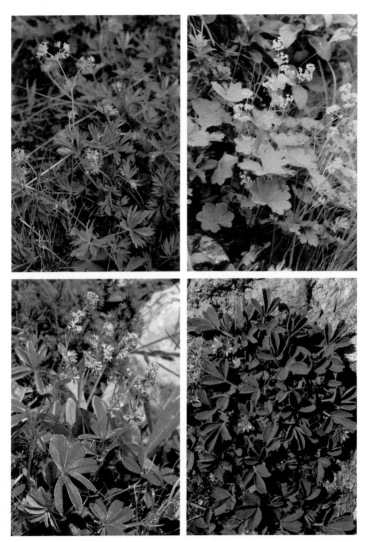

1. Five-fingered lady's mantle
 (Alchemilla pentaphyllea). ½ × .

2. Common lady's mantle
 (Alchemilla vulgaris). ⅕ × .

3. Alpine lady's mantle
 (Alchemilla alpina). ½ × .

4. Sibbaldia
 (Sibbaldia procumbens). ½ × .

Plate 50 see also p. 180–181

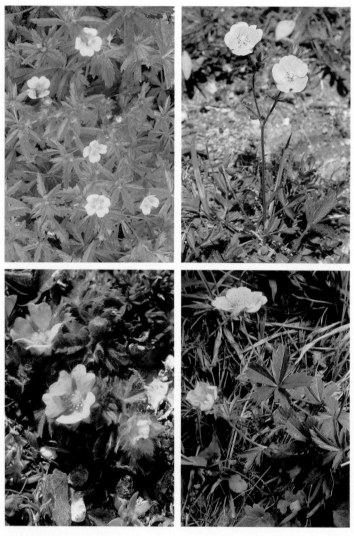

1. Tormentil
 (*Potentilla erecta*). ⅔ ×.

2. Large-flowered cinquefoil
 (*Potentilla grandiflora*). ⅓ ×.

3. Frigid cinquefoil
 (*Potentilla frigida*). 1½ ×.

4. Golden cinquefoil
 (*Potentilla aurea*). ⅔ ×.

Plate 51

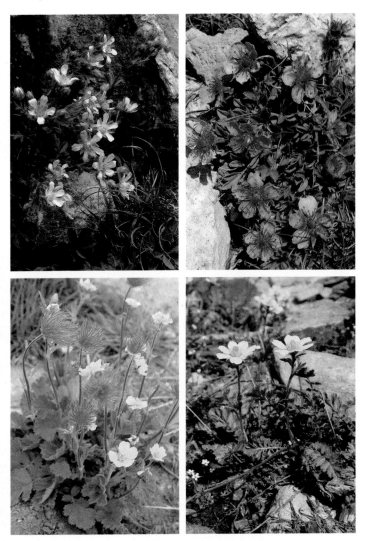

1. Caulescent cinquefoil
 (Potentilla caulescens). ⅓ ×.

2. Glossy cinquefoil
 (Potentilla nitida). ⅓ ×.

3. Alpine avens
 (Geum montanum). ¼ ×.

4. Creeping avens
 (Geum reptans). ¼ ×.

Plate 52 see also p. 183

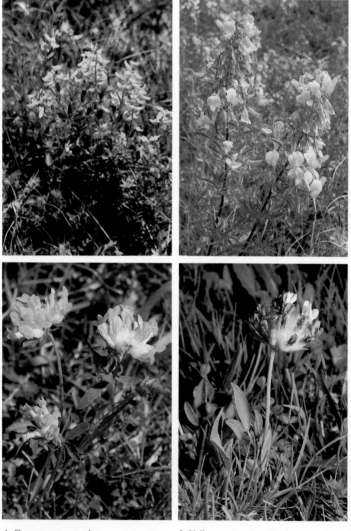

1. German greenweed
 (Genista germanica). ¼ × .

2. Yellow goatroot
 (Ononis natrix). ¼ × .

3. Alpine kidney-vetch
 (Anthyllis alpestris). ¾ × .

4. Cherler's kidney-vetch
 (Anthyllis cherleri). ¾ × .

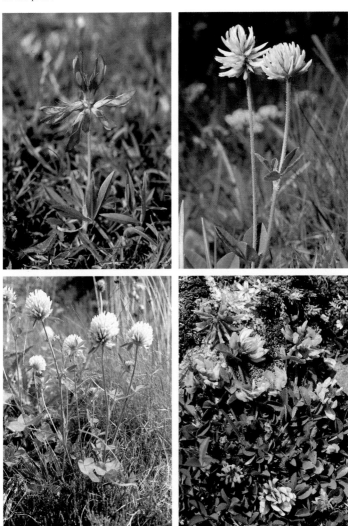

1. Alpine clover
 (Trifolium alpinum). ½ ×.

2. Mountain clover
 (Trifolium montanum). ⅔ ×.

3. Snow clover
 (Trifolium nivale). ¼ ×.

4. Thal's clover
 (Trifolium thalii). ½ ×.

Plate 54

see also p. 184–185

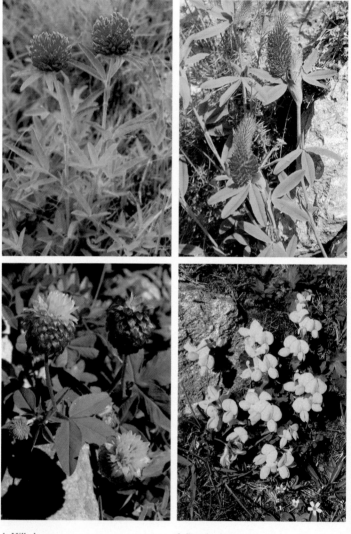

1. Hill clover
 (Trifolium alpestre). ⅓ ×.

2. Purple clover
 (Trifolium rubens). ¼ ×.

3. Brown clover
 (Trifolium badium). ¾ ×.

4. Alpine birdsfoot-trefoil
 (Lotus alpinus). ⅔ ×.

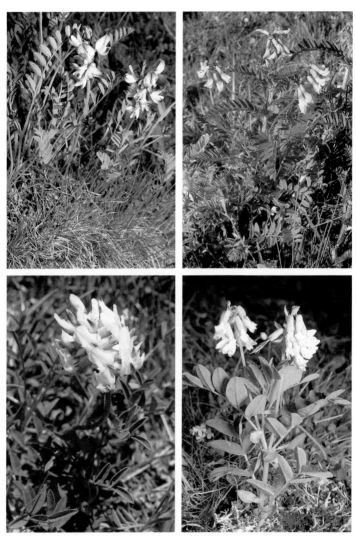

1. Alpine milk-vetch
 (*Astragalus alpinus*). ½ ×.

2. Droopy-flowered milk-vetch
 (*Astragalus penduliflorus*). ⅓ ×.

3. Southern milk-vetch
 (*Astragalus australis*). ¾ ×.

4. Glacial milk-vetch
 (*Astragalus frigidus*). ½ ×.

Plate 56 see also p. 185–186

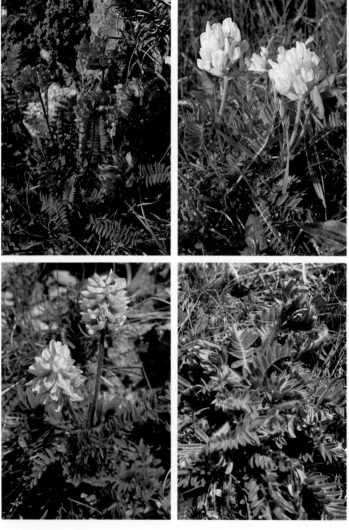

1. Jacquin's oxytropis
 (Oxytropis jacquinii). ½ × .

2. Yellow oxytropis
 (Oxytropis campestris). ½ × .

3. Downy-beaked oxytropis
 (Oxytropis pilosa). ½ × .

4. Haller's oxytropis
 (Oxytropis halleri). ½ × .

1. Horseshoe vetch
 (Hippocrepis comosa). ½ × .

2. Alpine crown-vetch
 (Coronilla vaginalis). ⅔ × .

3. Mountain sainfoin
 (Onobrychis montana). ⅓ × .

4. Alpine French honeysuckle
 (Hedysarum obscurum). ½ × .

Plate 58

see also p. 187–188

1. Meadow vetchling
 (Lathyrus pratensis). ½ ×.

2. Yellow everlasting vetchling
 (Lathyrus occidentalis). ⅕ ×.

3. Tufted vetch
 (Vicia cracca). ¼ ×.

4. Wood vetch
 (Vicia silvatica). ⅓ ×.

1. Wood cranesbill
 (Geranium silvaticum). ⅔ × .

2. Dusky cranesbill
 (Geranium lividum). ¾ × .

3. Rivulet cranesbill
 (Geranium rivulare). ½ × .

4. Bloody cranesbill
 (Geranium sanguineum). ¼ × .

Plate 60 see also p. 188–189

1. Alpine flax
 (Linum alpinum). ⅛ ×.

2. Cypress spurge
 (Euphorbia cyparissias). ½ ×.

3. Shrubby milkwort
 (Polygala chamaebuxus). ⅔ ×.

4. Subalpine milkwort
 (Polygala alpestris). ¾ ×.

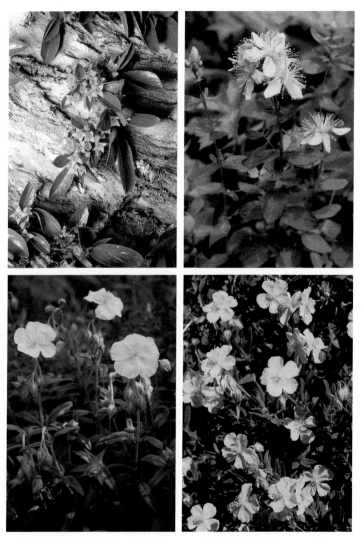

1. Dwarf buckthorn
 (*Rhamnus pumila*). ⅔ ×.

2. Spotted St-John's wort
 (*Hypericum maculatum*). ¾ ×.

3. Large-flowered rockrose
 (*Helianthemum grandiflorum*). ⅔ ×.

4. Alpine rockrose
 (*Helianthemum alpestre*). ¾ ×.

Plate 62 see also p. 191–192

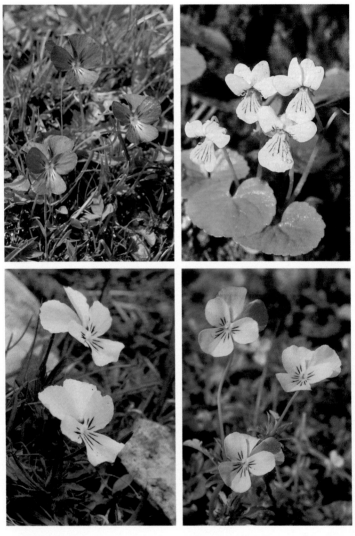

1. Alpine pansy
 (Viola calcarata). ½ × .

2. Two-flowered violet
 (Viola biflora). 1¼ × .

3. Mountain pansy
 (Viola lutea). ¾ × .

4. Wild pansy
 (Viola tricolor). 1 × .

Plate 63

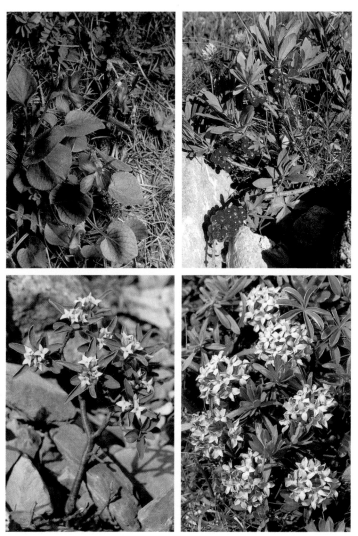

1. Sand violet
 (Viola rupestris). ¾ × .

2. Common mezereon
 (Daphne mezereum). ⅕ × .

3. Alpine mezereon
 (Daphne alpina). ⅓ × .

4. Striated mezereon
 (Daphne striata). ½ × .

Plate 64

see also p. 194

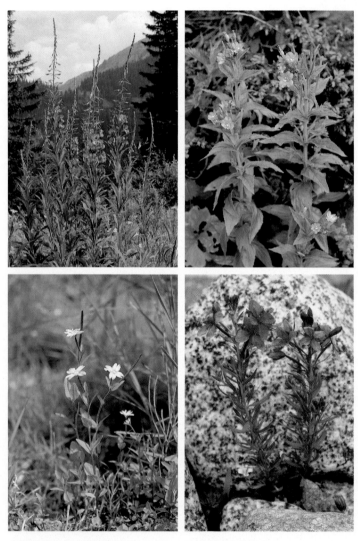

1. Narrow-leaved willowherb
 (*Epilobium angustifolium*). ¹⁄₁₀ ×.

2. Alpine willowherb
 (*Epilobium alpestre*). ¹⁄₄ ×.

3. Chickweed willowherb
 (*Epilobium alsinifolium*). ¹⁄₂ ×.

4. Fleischer's willowherb
 (*Epilobium fleischeri*). ¹⁄₃ ×.

Plate 65

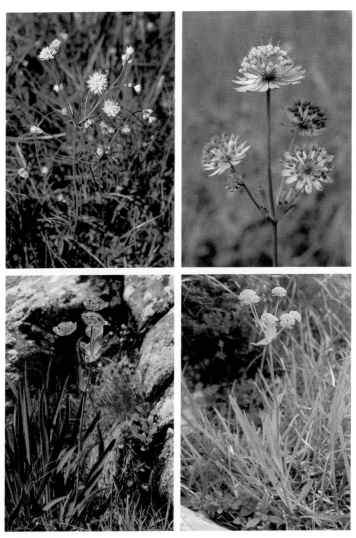

1. Small masterwort
 (*Astrantia minor*). ⅓ ×.

2. Big masterwort
 (*Astrantia major*). ⅔ ×.

3. Stellar hare's-ear
 (*Bupleurum stellatum*). ⅓ ×.

4. Crowfoot-leaved hare's-ear
 (*Bupleurum ranunculoides*). ⅓ ×.

Plate 66 see also p. 196

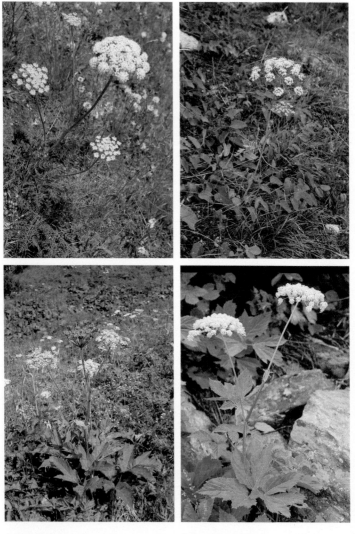

1. Haller's laser
 (Laserpitium halleri). ⅕ × .

2. Broad-leaved laser
 (Laserpitium latifolium). ⅛ × .

3. Common hogweed
 (Heracleum sphondylium). ¹⁄₁₂ × .

4. Masterwort
 (Peucedanum ostruthium). ⅛ × .

see also p. 198–199 **Plate 67**

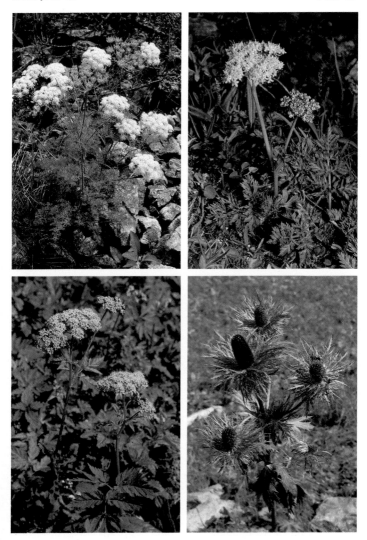

1. Athamantha
 (Athamanta cretensis). ¼ × .
2. Alpine lovage
 (Ligusticum mutellina). ⅓ × .
3. Mountain chervil
 (Chaerophyllum cicutaria). ¼ × .
4. Alpine eryngo
 (Eryngium alpinum). ⅓ × .

Plate 68 see also p. 200

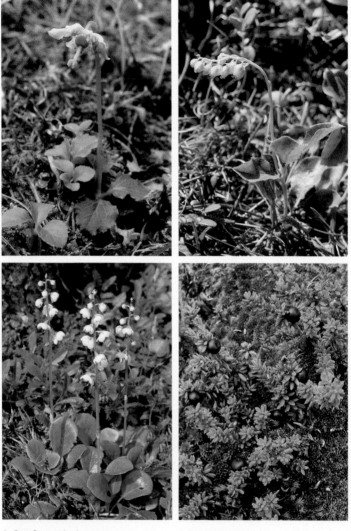

1. One-flowered wintergreen
 (Pyrola uniflora). ¾ × .

2. Serrated wintergreen
 (Pyrola secunda). ¾ × .

3. Round-leaved wintergreen
 (Pyrola rotundifolia). ⅓ × .

4. Crowberry
 (Empetrum hermaphroditum). ½ × .

Plate 69

1. Ling heather
 (Calluna vulgaris). ⅓ × .

2. Common heath
 (Erica carnea). ½ × .

3. Hairy alpenrose
 (Rhododendron hirsutum). ⅓ × .

4. Rust-leaved alpenrose
 (Rhododendron ferrugineum). ⅕ × .

Plate 70

see also p. 202

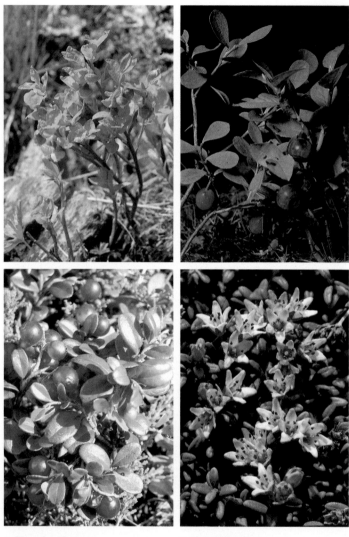

1. Flowering blueberry
 (Vaccinium myrtillus). ½ × .

2. Left: alpine bilberry
 (Vaccinium gaultherioides);
 right: blueberry
 (Vaccinium myrtillus). ¾ × .

3. Cowberry
 (Vaccinium vitis-idaea). ¾ × .

4. Trailing azalea
 (Loiseleuria procumbens). 1½ × .

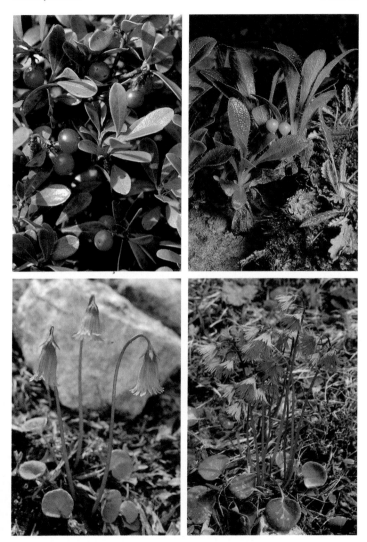

1. Common bearberry
 (Arctostaphylos uva-ursi). ¾ × .

2. Alpine bearberry
 (Arctostaphylos alpina). ⅔ × .

3. Delicate snowbell
 (Soldanella pusilla). 1 × .

4. Alpine snowbell
 (Soldanella alpina). ½ × .

Plate 72 see also p. 203–204

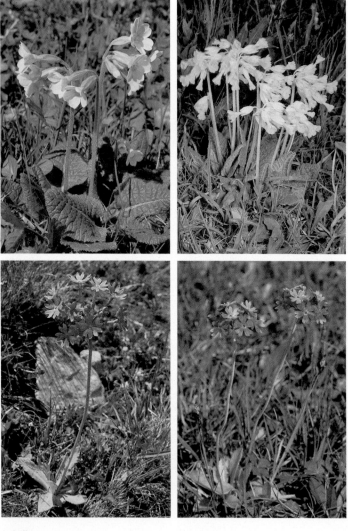

1. Oxlip
 (*Primula elatior*). ½ × .

2. Cowslip
 (*Primula veris*). ⅓ × .

3. Haller's primrose
 (*Primula halleri*). ⅓ × .

4. Bird's-eye primrose
 (*Primula farinosa*). ½ × .

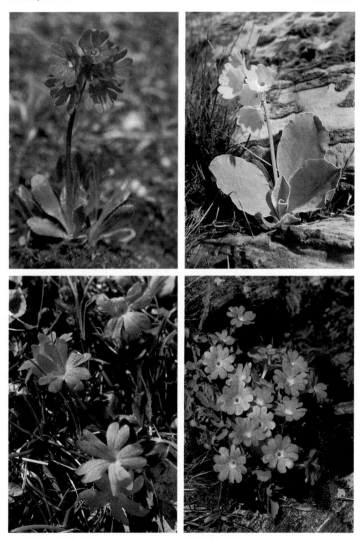

1. Glutinous primrose
 (Primula glutinosa). 1 × .

2. Auricula
 (Primula auricula). ½ × .

3. Entire-leaved primrose
 (Primula integrifolia). 1 × .

4. Stinking primrose
 (Primula hirsuta). ½ × .

Plate 74 see also p. 205–206

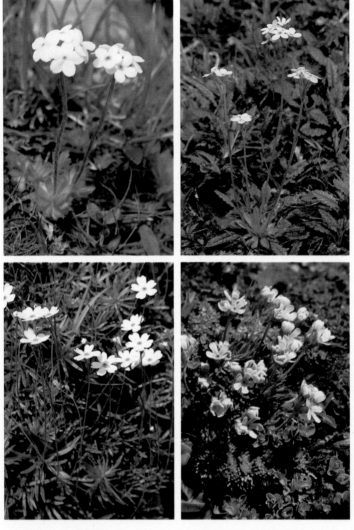

1. Ciliated rock-jasmine
 (*Androsace chamaejasme*). 1×.

2. Rock-jasmine with obtuse leaves
 (*Androsace obtusifolia*). ⅔×.

3. Milk-white rock-jasmine
 (*Androsace lactea*). ⅔×.

4. Flesh-coulored rock-jasmine
 (*Androsace carnea*). ⅔×.

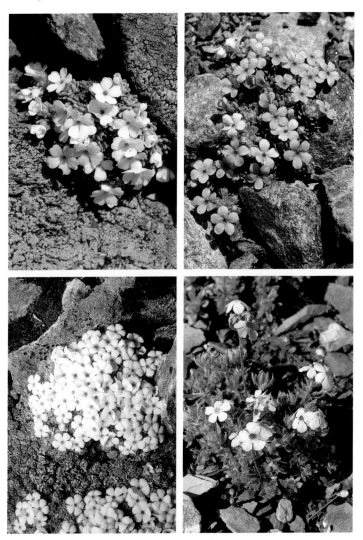

1. Vandelli's rock-jasmine
 (Androsace vandellii). 1½ ×.

2. Alpine rock-jasmine
 (Androsace alpina). 1 ×.

3. Swiss rock-jasmine
 (Androsace helvetica). 1 ×.

4. Woolly rock-jasmine
 (Androsace villosa). 1 ×.

Plate 76 see also p. 207–208

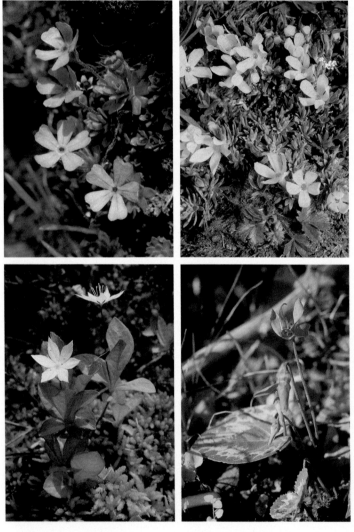

1. Charpentier's rock-jasmine
 (*Androsace brevis*). 2 × .

2. Yelow rock-jasmine
 (*Androsace vitaliana*). ¾ × .

3. Chickweed wintergreen
 (*Trientalis europaea*). ¾ × .

4. European cyclamen
 (*Cyclamen europaeum*). ⅓ × .

Plate 77

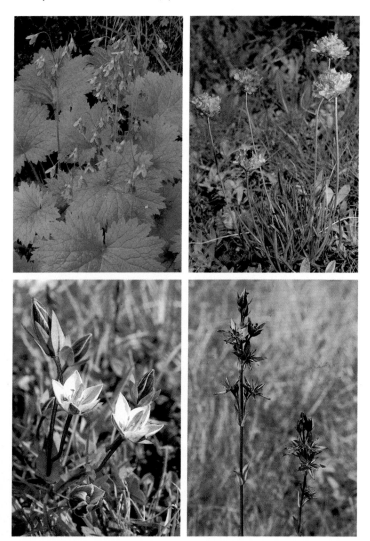

1. Cortusa
 (Cortusa matthioli). ⅓ × .

2. Alpine thrift
 (Armelia alpina). ⅓ × .

3. Carinthian felwort
 (Lomatogonium carinthiacum). ¾ × .

4. Marsh felwort
 (Swertia perennis). ⅓ × .

Plate 78

see also p. 209–210

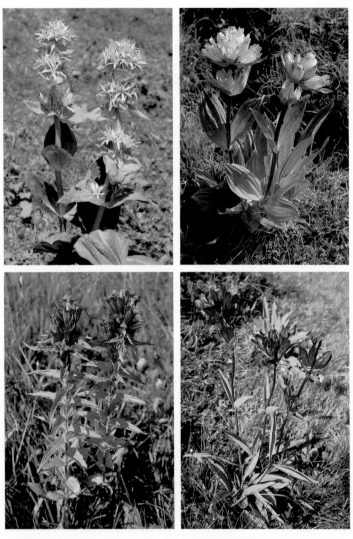

1. Yellow gentian
 (Gentiana lutea). ⅛ × .

2. Dotted gentian
 (Gentiana punctata). ⅕ × .

3. Willow gentian
 (Gentiana asclepiadea). ⅕ × .

4. Purple gentian
 (Gentiana purpurea). ⅙ × .

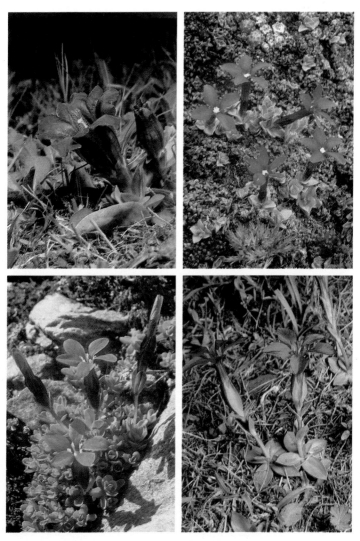

1. Koch's gentian
 (Gentiana kochiana). ½ × .

2. Short-leaved gentian
 (Gentiana brachyphylla). ½ × .

3. Bavarian gentian
 (Gentiana bavarica). ⅔ × .

4. Spring gentian
 (Gentiana verna). ⅔ × .

Plate 80

see also p. 211–212

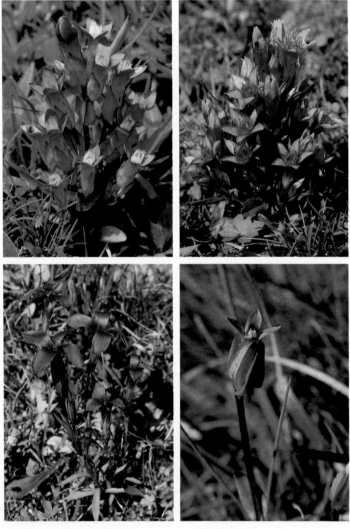

1. Field gentian
 (Gentiana campestris). ⅔ ×.

2. Branched gentian
 (Gentiana ramosa). ⅔ ×.

3. Fringed gentian
 (Gentiana ciliata). ⅔ ×.

4. Tender gentian
 (Gentiana tenella). 2 ×.

Plate 81

1. Snow gentian
 (Gentiana nivalis). 1 × .

2. Inflated gentian
 (Gentiana utriculosa). ⅔ × .

3. Vincetoxicum
 (Vincetoxicum officinale). ⅓ × .

4. Common dodder
 (Cuscuta epithymum). ⅔ × .

Plate 82　　　　　　　　　　　　　　　　　　　　see also p. 213–214

1. Jacob's ladder
 (*Polemonium coeruleum*). ⅔ × .

2. Viper's bugloss
 (*Echium vulgare*). ¼ × .

3. Narrow-leaved lungwort
 (*Pulmonaria angustifolia*). ½ × .

4. Glabrous cerinthe
 (*Cerinthe glabra*). ½ × .

Plate 83

1. Alpine forget-me-not
 (Myosotis alpestris). ½ × .

2. King of the Alps
 (Eritrichium nanum). ⅔ × .

3. Mountain germander
 (Teucrium montanum). ½ × .

4. Dragonhead of Ruysch
 (Dracocephalum ruyschiana). ⅓ × .

Plate 84

see also p. 215–216

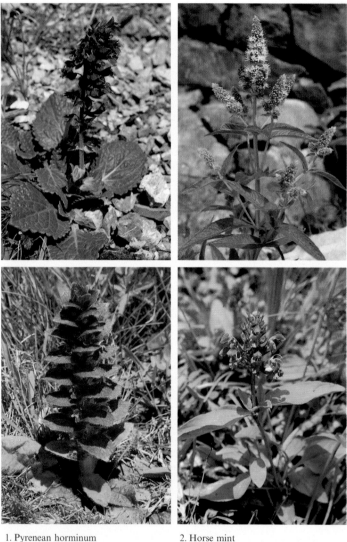

1. Pyrenean horminum
 (*Horminum pyrenaicum*). ⅓ × .

2. Horse mint
 (*Mentha longifolia*). ⅓ × .

3. Pyramidal bugle
 (*Ajuga pyramidalis*). ½ × .

4. Large selfheal
 (*Prunella grandiflora*). ½ × .

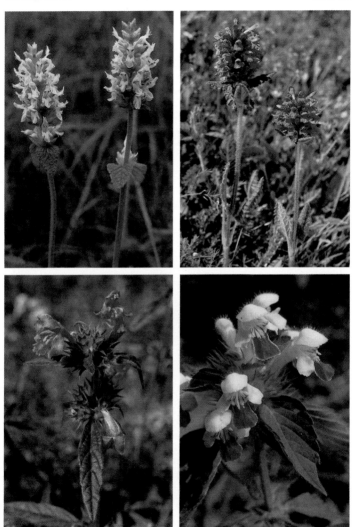

1. Fox-tail betony
 (Betonica alopecuros). ½ × .

2. Dense-flowered betony
 (Betonica hirsuta). ½ × .

3. Narrow-leaved hemp-nettle
 (Galeopsis angustifolia). ¾ × .

4. Large-flowered hemp-nettle
 (Galeopsis speciosa). 1 × .

Plate 86 see also p. 217

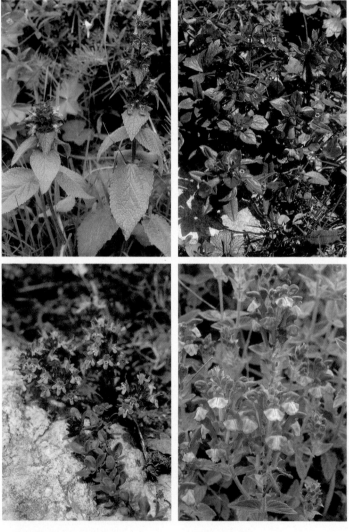

1. Limestone woundwort
 (Stachys alpina). ⅓ ×.

2. Alpine calamint
 (Satureja alpina). ½ ×.

3. Wild thyme
 (Thymus polytrichus). ¾ ×.

4. Alpine scullcap
 (Scutellaria alpina). ½ ×.

Plate 87

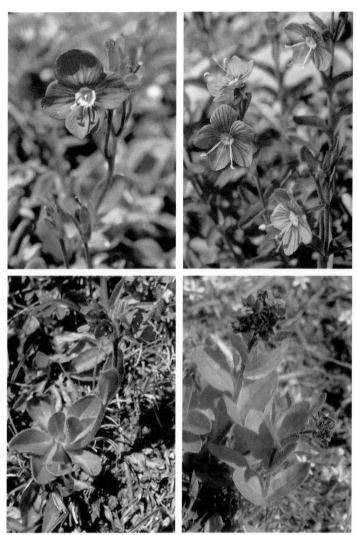

1. Rock speedwell
 (Veronica fruticans). 2 × .

2. Shrubby speedwell
 (Veronica fruticulosa). 1½ × .

3. Daisy-leaved speedwell
 (Veronica bellidioides). ¾ × .

4. Alpine speedwell
 (Veronica alpina). 1 × .

Plate 88 see also p. 218–219

1. Leafless speedwell
 (*Veronica aphylla*). ⅔ ×.

2. Tender speedwell
 (*Veronica tenella*). ⅔ ×.

3. Alpine toadflax
 (*Linaria alpina*). ½ ×.

4. Alpine balsam
 (*Erinus alpinus*). ½ ×.

Plate 89

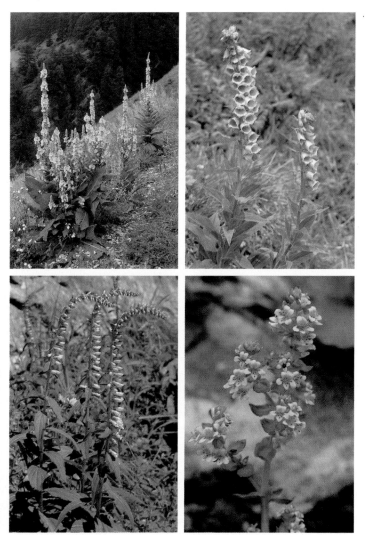

1. Thick-leaved mullein
 (*Verbascum crassifolium*). ¹⁄₁₅ × .
2. Big-flowered foxglove
 (*Digitalis grandiflora*). ¹⁄₈ × .
3. Small yellow foxglove
 (*Digitalis lutea*). ¹⁄₈ × .
4. Alpine tozzia
 (*Tozzia alpina*). ³⁄₄ × .

Plate 90 see also p. 220–221

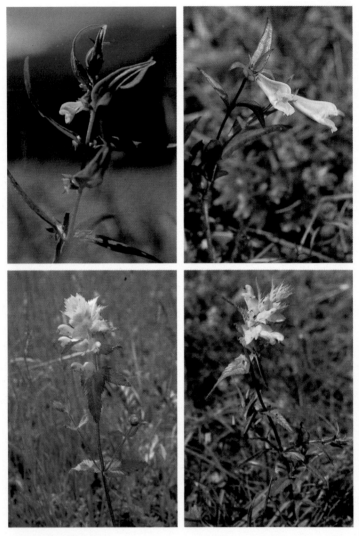

1. Wood cow-wheat
 (*Melampyrum silvaticum*). 1 × .

2. Common cow-wheat
 (*Melampyrum pratense*). 1 × .

3. Hairy yellow-rattle
 (*Rhinanthus alectorolophus*). ⅓ × .

4. Narrow-leaved yellow-rattle
 (*Rhinanthus angustifolius*). ⅓ × .

Plate 91

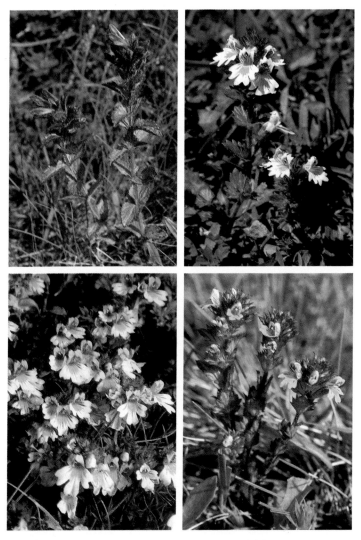

1. Alpine bartsia
 (Bartsia alpina). ½ × .

2. Common eye-bright
 (Euphrasia rostkoviana). 1 × .

3. Alpine eye-bright
 (Euphrasia alpina). 1 × .

4. Dwarf eye-bright
 (Euphrasia minima). 1 × .

Plate 92 see also p. 222–223

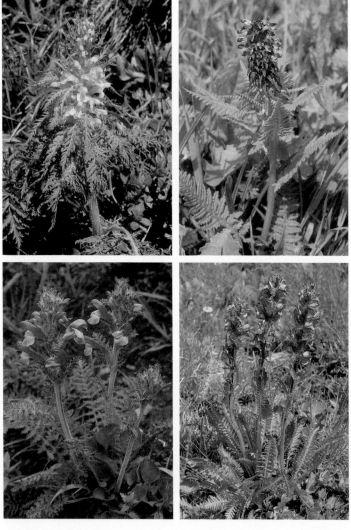

1. Foliated lousewort
 (Pedicularis foliosa). ⅓ ×.

2. Skinned lousewort
 (Pedicularis recutita). ⅓ ×.

3. Arched lousewort
 (Pedicularis gyroflexa). ½ ×.

4. Capitate lousewort
 (Pedicularis rostrato-spicata). ⅓ ×.

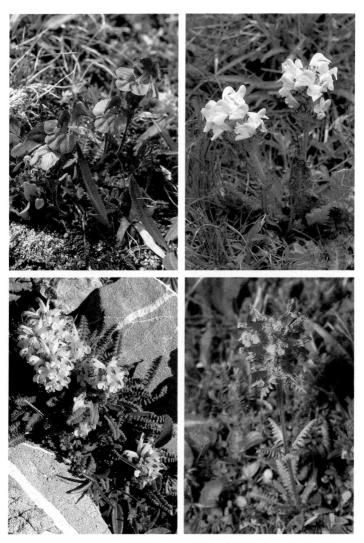

1. Kerner's lousewort
 (Pedicularis kerneri). ¾ × .

2. Tuberous lousewort
 (Pedicularis tuberosa). ½ × .

3. Oeder's lousewort
 (Pedicularis oederi). ½ × .

4. Whorled lousewort
 (Pedicularis verticillata). ½ × .

Plate 94 see also p. 225–226

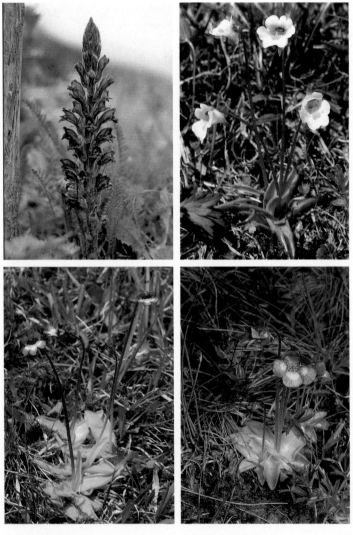

1. Purple broomrape
 (Orobanche purpurea). ⅓ × .

2. Alpine butterwort
 (Pinguicula alpina). ¾ × .

3. Common butterwort
 (Pinguicula vulgaris). ½ × .

4. Hairy-spurred butterwort
 (Pinguicula leptoceras). ⅔ × .

see also p. 225–226 **Plate 95**

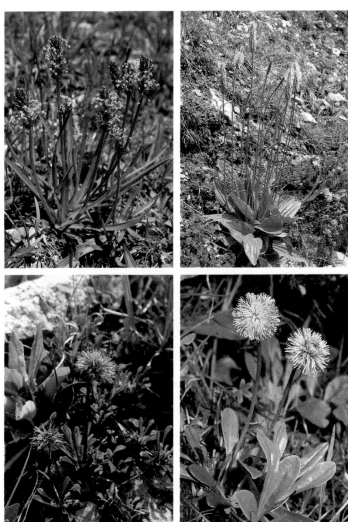

1. Alpine plantain
 (Plantago alpina). ½ ×.

2. Medium plantain
 (Plantago media). ¼ ×.

3. Heart-leaved globularia
 (Globularia cordifolia). ⅔ ×.

4. Bald-stemmed globularia
 (Globularia nudicaulis). ⅔ ×.

Plate 96　　　　　　　　　　　　　　　see also p. 226–227

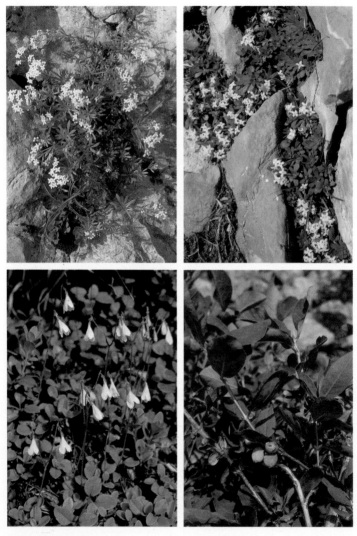

1. Dwarf bedstraw
 (Galium anisophyllum). ¼ × .

2. Swiss bedstraw
 (Galium helveticum). ½ × .

3. Northern twinflower
 (Linnaea borealis). ⅓ × .

4. Blue-berried honeysuckle
 (Lonicera coerulea). ½ × .

Plate 97

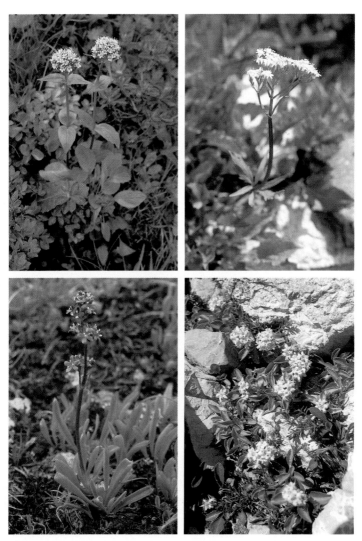

1. Mountain valerian
 (Valeriana montana). ⅙ ×.

2. Three-leaved valerian
 (Valeriana tripteris). ⅓ ×.

3. Spikenard
 (Valeriana celtica). ⅔ ×.

4. Dwarf valerian
 (Valeriana supina). ⅓ ×.

Plate 98 see also p. 230–231

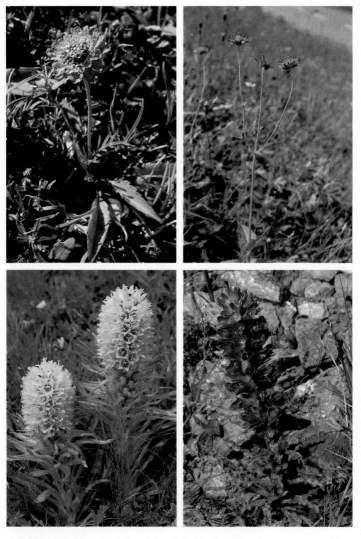

1. Bright scabious
 (Scabiosa lucida). ½ ×.

2. Wood scabious
 (Knautia silvatica). ⅙ ×.

3. Tufted bellflower
 (Campanula thyrsoides). ¼ ×.

4. Spiked bellflower
 (Campanula spicata). ¼ ×.

Plate 99

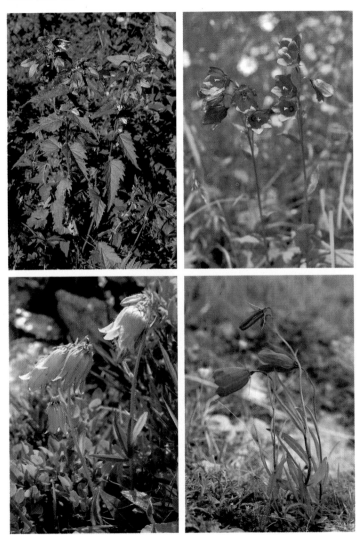

1. Broad-leaved bellflower
 (Campanula latifolia). ⅛ ×.
2. Rhomboid-leaved bellflower
 (Campanula rhomboidalis). ⅓ ×.
3. Bearded bellflower
 (Campanula barbata). ½ ×.
4. Scheuchzer's bellflower
 (Campanula scheuchzeri). ½ ×.

Plate 100 see also p. 232–233

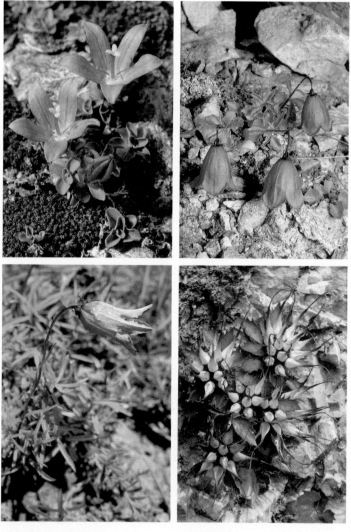

1. Mt. Cenis bellflower
 (Campanula cenisia). 1 × .
2. Small bellflower
 (Campanula cochleariifolia). ¾ × .
3. Incised bellflower
 (Campanula excisa). 1 × .
4. Tassel rampion
 (Synotoma comosum). ½ × .

Plate 101

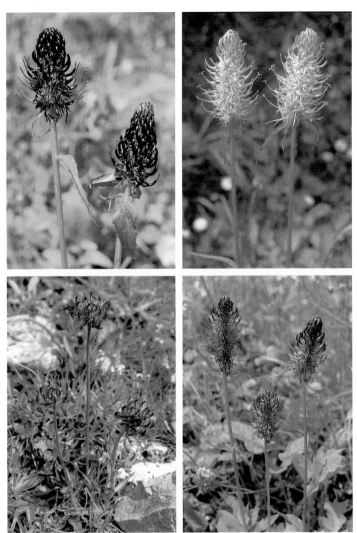

1. Oval-headed rampion
 (*Phyteuma ovatum*). ½ × .
2. Spiked rampion
 (*Phyteuma spicatum*). ½ × .
3. Round-headed rampion
 (*Phyteuma orbiculare*). ½ × .
4. Betony-leaved rampion
 (*Phyteuma betonicifolium*). ½ × .

Plate 102 see also p. 234

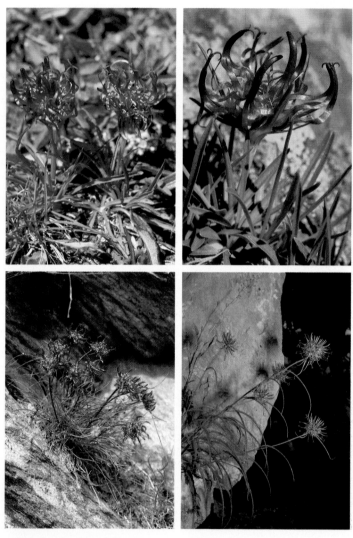

1. Globularia-leaved rampion
 (Phyteuma globulariifolium). 1 × .

2. Dwarf rampion
 (Phyteuma humile). 2 × .

3. Hemispherical rampion
 (Phyteuma hemisphaericum). ⅓ × .

4. Scheuchzer's rampion
 (Phyteuma scheuchzeri). ¼ × .

see also p. 235–236 **Plate 103**

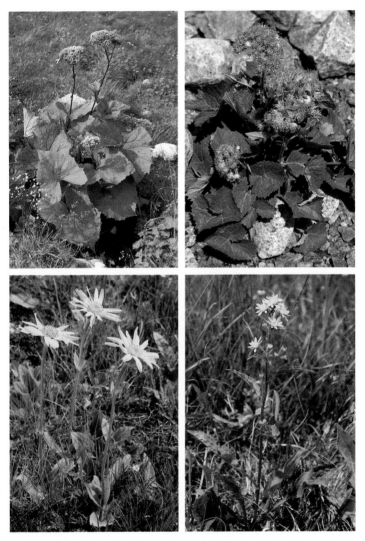

1. Hedge-leaved adenostyle
 (*Adenostyles alliariae*). ¹⁄₁₂ × .

2. White-leaved adenostyle
 (*Adenostyles leucophylla*). ¹⁄₆ × .

3. Mountain arnica
 (*Arnica montana*). ¹⁄₄ × .

4. Alpine goldenrod
 (*Solidago alpestris*). ¹⁄₃ × .

Plate 104

see also p. 236–237

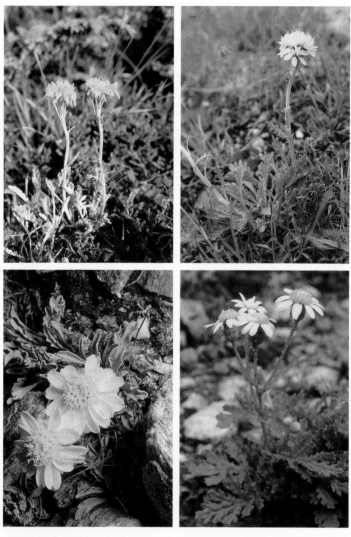

1. Hoary groundsel
 (Senecio incanus). ⅓ × .

2. Carniol groundsel
 (Senecio carniolicus). ½ × .

3. One-headed groundsel
 (Senecio uniflorus). ¾ × .

4. Rock groundsel
 (Senecio rupester). ⅔ × .

Plate 105

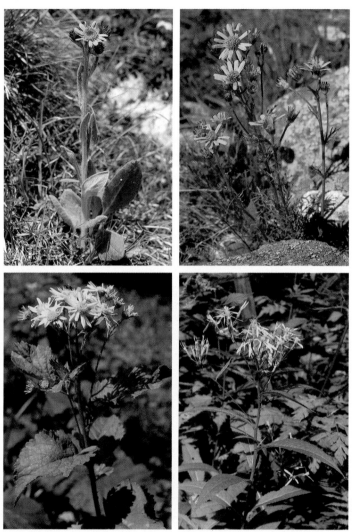

1. Orange groundsel
 (Senecio capitatus). ⅓ ×.

2. Abrotanum-leaved groundsel
 (Senecio abrotanifolius). ⅓ ×.

3. Alpine groundsel
 (Senecio alpinus). ⅓ ×.

4. Fuchs's groundsel
 (Senecio fuchsii). ¼ ×.

Plate 106　　　　　see also p. 237–239

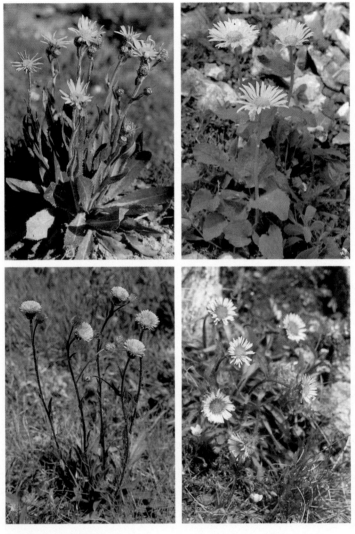

1. Leopard's-bane groundsel
 (Senecio doronicum). ¼ × .

2. Large-flowered leopard's-bane
 (Doronicum grandiflorum). ¼ × .

3. Alpine fleabane
 (Erigeron alpinus). ⅓ × .

4. One-flowered fleabane
 (Erigeron uniflorus). ½ × .

Plate 107

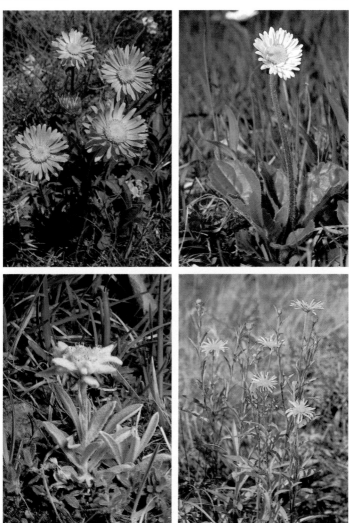

1. Alpine aster
 (Aster alpinus). ⅓ × .

2. Micheli's daisy
 (Bellidiastrum michelii). ½ × .

3. Edelweiss
 (Leontopodium alpinum). ½ × .

4. Yellow ox-eye
 (Buphtalmum salicifolium). ⅙ × .

Plate 108 see also p. 240–241

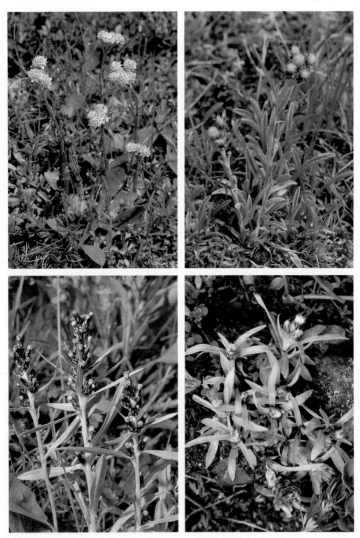

1. Common pussytoes
 (Antennaria dioeca). ½ × .

2. Carpathian pussytoes
 (Antennaria carpatica). ½ × .

3. Wood cudweed
 (Gnaphalium silvaticum). ½ × .

4. Dwarf cudweed
 (Gnaphalium supinum). ¾ × .

see also p. 241–242 **Plate 109**

1. Genipi wormwood
 (Artemisia genipi). ½ × .

2. Noble wormwood
 (Artemisia mutellina). ½ × .

3. Glacial wormwood
 (Artemisia glacialis). ½ × .

4. Dwarf yarrow
 (Achillea nana). ⅔ × .

Plate 110 see also p. 242

1. Clavena's yarrow
 (*Achillea clavenae*). 1×.

2. Large-leaved yarrow
 (*Achillea macrophylla*). ½×.

3. Musk yarrow
 (*Achillea moschata*). ½×.

4. Black yarrow
 (*Achillea atrata*). ⅓×.

1. Erect yarrow
 (*Achillea stricta*). ⅙ ×.

2. Mountain marguerite
 (*Chrysanthemum adustum*). ⅕ ×.

3. Alpine marguerite
 (*Chrysanthemum alpinum*). ¼ ×.

4. Haller's marguerite
 (*Chrysanthemum halleri*). ¼ ×.

Plate 112

see also p. 244

1. Paradoxal butterbur
 (Petasites paradoxus). ¼ × .

2. White butterbur
 (Petasites albus). ⅓ × .

3. Coltsfoot
 (Tussilago farfara). ¾ × .

4. Alpine coltsfoot
 (Homogyne alpina). ½ × .

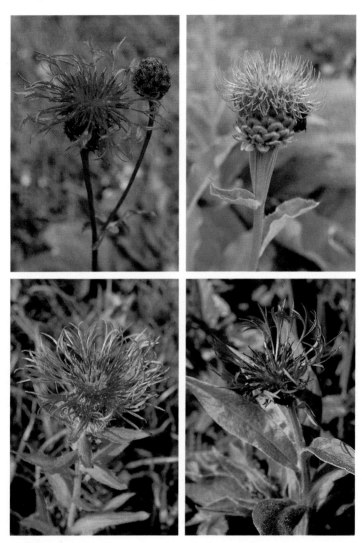

1. Alpine knapweed
 (Centaurea alpestris). ⅔ × .

2. Scarious giant knapweed
 (Rhaponticum scariosum). ⅓ × .

3. Nerved knapweed
 (Centaurea nervosa). ⅔ × .

4. Mountain knapweed
 (Centaurea montana). ½ × .

Plate 114 see also p. 245–246

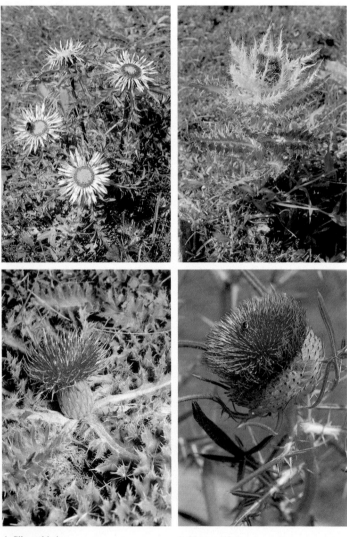

1. Silver thistle
 (*Carlina simplex*). ⅙ ×.

2. Thorny thistle
 (*Cirsium spinosissimum*). ¼ ×.

3. Stemless thistle
 (*Cirsium acaule*). ⅔ ×.

4. Woolly thistle
 (*Cirsium eriphorum*). ½ ×.

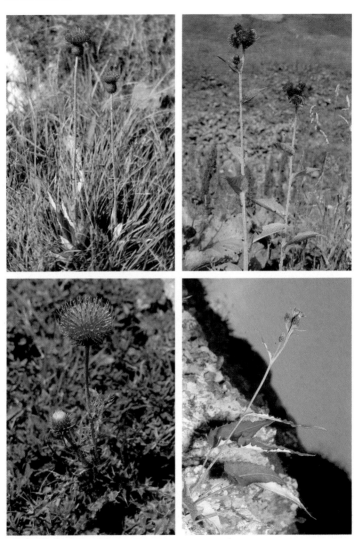

1. Melancholy thistle
 (*Cirsium helenioides*). ⅙ ×.

2. Great marsh thistle
 (*Carduus personata*). ⅙ ×.

3. Smooth-stemmed thistle
 (*Carduus defloratus*). ½ ×.

4. Tomentose sawwort
 (*Saussurea discolor*). ¼ ×.

Plate 116

see also p. 247–248

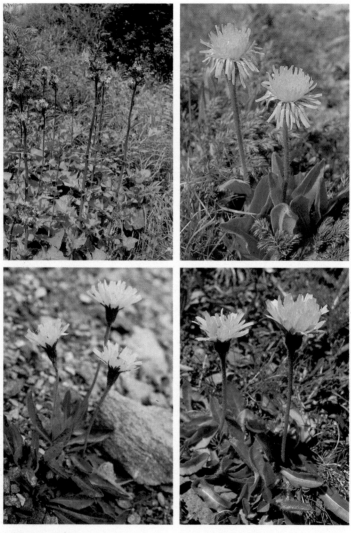

1. Blue sow-thistle
 (*Cicerbita alpina*). ¹⁄₁₀ × .

2. One-headed cat's-ear
 (*Hypochoeris uniflora*). ¹⁄₃ × .

3. Swiss hawkbit
 (*Leontodon helveticus*). ¹⁄₂ × .

4. Rough hawkbit
 (*Leontodon hispidus*). ¹⁄₂ × .

1. Mountain hawkbit
 (Leontodon montanus). ⅔ × .

2. Alpine dandelion
 (Taraxacum alpinum). ½ × .

3. Hawk's-beard of Mt. Triglav
 (Crepis terglouensis). ⅔ × .

4. Dwarf hawk's-beard
 (Crepis pygmaea). ½ × .

Plate 118 see also p. 249–250

1. Mountain hawk's-beard
 (Crepis pontana). ⅓ ×.

2. Golden hawk's-beard
 (Crepis aurea). ½ ×.

3. Larger hawk's-beard
 (Crepis conyzifolia). ¼ ×.

4. Jacquin's hawk's-beard
 (Crepis jacquinii). ½ ×.

1. Hare lettuce
 (Prenanthes purpurea). ½ ×.

2. Mouse-ear hawkweed
 (Hieracium pilosella). ½ ×.

3. Prenanth hawkweed
 (Hieracium prenanthoides). ⅛ ×.

4. Orange hawkweed
 (Hieracium aurantiacum). ¼ ×.

Plate 120 see also p. 251–252

1. Woolly hawkweed
 (Hieracium villosum). ¼ ×.

2. Whitish hawkweed
 (Hieracium intybaceum). ⅓ ×.

3. Statice-leaved hawkweed
 (Hieracium staticifolium). ⅓ ×.

4. Alpine hawkweed
 (Hieracium alpinum). ½ ×.